D0088585

ABOUT THE TRANSLATOR

Dr. Nevit O. Ergin was born in Turkey from where he emigrated first to Canada, and then to the United States to pursue his postgraduate medical work. He has traveled extensively throughout the world, particularly in Central Asia and the Near and Far East. Dr. Ergin currently lives in Southern California where he practices medicine and works with The Society for Understanding Mevlana. The Society is a non-profit organization dedicated to continued study, translation, and understanding of Rumi and his works.

Printed in The United States of America
ISBN: 0-934252-30-0

Cover illustration: Persian Miniature

Published by Hohm Press • P.O. Box 2501 • Prescott, Arizona 86302
(602) 778-9189

CRAZY AS WE ARE

Selected Rubais from Divan-i Kebir
by
Mevlana Celaleddin Rumi

Introduction and Translation by Dr. Nevit O. Ergin

HOHM PRESS

□ ■ □

MEVLANA CELALEDDIN RUMI

by Dr. Nevit O. Ergin

Mevlana Celaleddin (Celal) Rumi is one of the greatest mystics of all time—bigger than life, yet close to humanity, and able to dissolve all religious and racial boundaries.

Mevlana lived in Asia Minor in the 13th century. All of his earthly beginnings are surrounded by controversy, including his date of birth. The historian Eflaki puts it as September 29, 1207. However, by Mevlana's own account in *Fihi Mafih*, the siege of Semerkand took place in 1203, and he was there. Moveover, according to Golpinarli (1985), Mevlana met Shems of Tebriz on November 26, 1244; indirectly in his *Divan* he refers to meeting Shems when he was 62 years old. This puts his birthday as June 6, 1184.[1]

There is also serious doubt as to Mevlana's father's kinship to First Caliph Ebu Bekr[2] or his mother's to the Kharezm-Shah's.[3]

On the other hand, there is no controversy about the presence of tumultuous religious and political forces throughout Asia Minor at the end of the 12th century.

Immediately after the Christian Crusades the Seljug Turks reached their zenith, controlling all of Asia Minor, Persia and, in the 10th and 11th centuries, part of Asia. They were Islamic, Turkic people. Although the Arabs brought Islam to the Persians (the most ancient people of the Middle East), Arabic Islam did not conquer the Turks. On the contrary, the Turks entered the Islamic world as conquerors. Some of them freely converted in their homeland.[4]

The declining stages of the Seljug dynasty in the area of the Persian Gulf brought the Kharezm-Shahs to major power in the whole region, this time from east to west. This is significant for a number of reasons.

First, the Kharezm-Shahs were notoriously involved in slaying venerable saints and scholars who did not agree with their way of thinking. During this period, however, some of the most unforgettable spiritual members of the human race lived and flourished, including Mevlana's father.

Second, one of the Kharezm-Shahs challenged the Caliph's position as Abbasid of Baghdad (the religious leader of Islam), fought with religious leaders who were of Persian origin, and declared a Shiite Arab as Caliph. This had political implications as well. While all this bickering was going on among the Islamic Turks, Genghis Khan, although still busy with the war of the Kin Empire, had already solidified his power, having taken part of China. He was looking for adventure in more fertile lands westward.

Genghis Khan lived in the Mongolian city of Karakorum (Black Sand) in a haphazardly built, ugly city, while the neighboring Kharezmian empire included beautiful cities such as Semerkand, Balkh, Herat, and Boukhara, center of Islam's academies and mosques. Accordingly, Genghis Khan sent trade envoys to the politically-weakened Kharezm.

And third, the Kharezm-Shah virtually invited the destruction of the region by Genghis Khan. Most historians agree that all the Mongol trouble started because of the Kharezm-Shah's stupidity during this initial trading between the two emperors. The Kharezmians were officially insisting that Genghis Khan not be recognized, and they killed Mongol envoys for no reason (1218). These obvious acts of aggression were enough to make Genghis Khan jump on his horse and gallop toward Turkistan, saying, "There cannot be two suns in heaven, nor two Khans on earth."[5]

This westward march of the Mongol army was devastating to the Islamic, Persian, and Turkic peoples, including the Kharezms, the Seljug Turks, and others in Transoxania who were Muslim Turkic people of Asian origin. But as previously mentioned, during this time spiritual activity reached astonishing heights.

Mevlana's father was himself a spiritual man. His name was Bahauddin Veled, Sultan of Scholars, or Mevlana Buzerg (the great master), extremely knowledgeable and authoritarian. Even before the threat of the Mongol invasion, Bahauddin was no stranger to controversy and danger. He was a scholar with the highest position at one of the colleges. He, probably the school he belonged to, and his teacher Necmeddin Kubra (who was killed by Mongols in 1221), espoused Being over philosophy, in particular the Neo-Platonic philosophy which was partially accepted by the Kharezm-Shah (Sultan Muhammed Tekesh Kharezm-Shah). This put him in direct conflict with the Kharezm-Shah.[6] And, in fact, none of the Kharezm rulers were friendly with the Bahauddin group.

There can be no doubt that Bahauddin foresaw the upcoming Mongol invasion. By 1221, he was in his seventies (he was 55 years old during the war between Kharezm and Gor in 1203) and Mevlana was 28 or 29 years old.

Although we will probably never know the exact causes, Mevlana's father did decide to migrate from Balkh in possibly 1221. (There is also historic controversy regarding this journey[7]). Like a prudent, experienced captain of his ship, he pulled his boat out of those turbulent waters just in time to miss the coming Mongols. The possible date of his arrival in Konya is 1228.

The family's first major stop was Baghdad, and before they left there they heard that a Mongol army of 500,000, commanded by Genghis, had destroyed Balkh.

They went on pilgrimage to Mecca, then to Asia Minor (Rum) which is now known as Turkey, and stayed in the eastern city of Malatya before moving on toward Konya.

In Larenda, a short distance from Konya, Mevlana married Gevher Khatun. Their first son, Sultan Veled, was born in 1226. Mevlana had a second son, Muhammed Alaeddin, but the date of his birth is unknown.

With the invitation of Seljug Sultan Alaeddin Keykubad (D. 1237), Bahauddin settled in Konya "where he was installed in a college and soon professed himself [Keykubad] as a disciple."[8] The atmosphere was excellent; Konya was the capital of the Seljug Turks, who tolerated diversity well.

Bahauddin lived only about two years after the family's arrival in Konya. He died on January 12, 1231. His son, Mevlana Celaleddin, took over the post as dean of the college, since he was the natural heir and qualified as well.

Mevlana was subsequently tutored by Seyid Burhaneddin, disciple of his father who arrived in Konya in 1232. From him Mevlana learned the "Mystery of Mute Reality and Ecstasy" and the "Science of Divine Intuition." Burhaneddin told him that he surpassed his father in all knowledge of humanities; however, like his father, he should be versed in other areas as well.[9] This association lasted about nine years. During these years Mevlana traveled to Damascus and Aleppo for more studies.

Mevlana's eldest son, Sultan Veled, tells us that after his tutor "Seyid's [Burhaneddin] sudden departure from this world of illusion to the world of reality [his death], Celal became very lonely. He turned his face to God day and night. He lost sleep and forgot to eat. For five years he did mortification of the flesh. His contrition raised him above the angels. His words and deeds appeared to be divinely inspired. The people who did not care for him before became his disciples. Jurists and religious leaders considered him holy."[10]

According to Eflaki, the Platonic monastery just outside of Konya was a place where Mevlana spent some time. It should be noted that Konya was not only the capital of the Seljug Turks, it was a city of education and religious tolerance. Besides the Moslem community, there were sizeable Greek and Jewish communities; along with the mosques, there were churches and monasteries.

A few years after the death of Mevlana's father, the king of Seljug died (1237). The new king, while trying to solidify his power against internal dissent, learned

that the Mongol army under the command of Bacu had taken the important Eastern city of Erzurum (1242). He still had to deal with the internal uprisings. Some of these were a pure power struggle, but they always had mystical and religious tones.

The social turmoil and lack of security in life set a fertile ground for Sufi organizations, especially with the influx of newcomers resulting from the Mongol dislocation from Asia to Asia Minor. These organizations became centers of spiritual escape from the harsh realities of the time; they were the only places where anyone could breathe. The authorities upholding strict religious laws tried to oppose these movements, but without much success. There were Sufi Dervishes of all kinds.

At the time, Mevlana was aware of the different Sufi groups, but the only one he belonged to was Melameti's (Melami's).[11] (Since Melameti originated in Horasan, it was sometimes called Horasani.) Several Sufi leaders had moved to Asia Minor from the East, centered around the elite and powerful groups, excluding ordinary people, and Melameti was a reaction to this trend. The Melameti denied titles, dress codes, and ceremonies, and developed tolerance. They did everything to be humiliated in order to destroy "Self." Mevlana was, in fact, a representative of this Melameti or Horansani group (first with his father, then later with Shems).

Then Shems came into Mevlana's life.

We would never have known Mevlana as we do now if he had not met Shems of Tebriz. When they first met on November 26, 1224, Mevlana and Shems were well over sixty years of age.

Who was Shems? Why did he go to Konya? Why and how did he meet Mevlana? There are details and colorful facts and fictions in the accounts of Eflaki, Sipahsalar and even Mevlana and Shems.

Seven hundred years later, Mr. H.L. Susud described Shems in this way: "What a Sun you were, oh, Shems of Tebriz, that one ray of your light became the Master [Mevlana] of the world."[12]

From the time they met, Mevlana's life is the story of Annihilation, from Being to Non-being, Existence to Non-existence, from Testimonial Knowledge to the Unseen.

According to Eflaki, Shems showed him the exit from Being, and taught him Extinction and the true nature of things by the removing of all condescension, by freedom from the body, and by changing perception from objectivity to subjectivity. He understood the source of theology and the origin of religion by realizing the Oneness in Action, Attributes, and Essence. His way was the way of Absolute Truth. To settle for less than that would be a big disservice to Mevlana.[13]

In Shems, Mevlana saw himself as Personified Divinity. But life around them, just like the period in which they lived, was extremely restless. Misunderstandings and jealousy had become everyday occurrences. These made life

unbearable for Shems. After staying in Konya with Mevlana for 15 months, Shems suddenly disappeared.

He returned to Konya on May 8, 1247 only after Mevlana had pleaded repeatedly and sent his son to Aleppo to get him. This time Shems married Mevlana's stepdaughter. The couple lived at the college in very modest circumstances compared with their contemporary religious dignitaries, like Sadreddin Konevi, Sheik of Islam of Konya, celebrated religious leader, stepson of Muhyeddin ibn 'i Arabi, who lived in a palace.

Once again there was controversy, even conspiracy, around Shems. This time, Mevlana's youngest son Alaeddin, who originally objected to Shems' marriage and closeness to his father, was against him.

The short-lived second reunion of Mevlana and Shems tragically ended December 5, 1247 with the assassination of Shems. Alaeddin has been implicated by many in the assassination.

Shems' return to Konya coincided with the defeat of Seljug ruler Giyaseddin by the Mongols. Asia Minor became another province of the Mongol Empire.

During these bleak times, we see an entirely different Mevlana, not just the Muslim scholar he was before he met Shems. He had become a man with Divine Ecstasy, reciting Odes and Rubai day and night and dancing (Sema, or Dervish dancing) to his own rhythm. The introduction of music and Sema was not new to the Moslem society, but it had never reached this level and intensity in any previous time.

The Muineddin Pervana (prime minister of the Seljug government) is reported to have said publicly that Celal was a matchless monarch; that no sovereign in any age was like unto him, but that his disciples were a very disreputable bunch. Celal sent a note to Pervana saying, "Had my disciples been good men, I would have been their disciple. Inasmuch as they were bad, I accepted them as my disciples that they might reform and become good."[14]

The people around Mevlana were from all walks of life, including farmers, public bath servants, artists, architects, barbers, merchants, singers, carpenters, butchers, and musicians. They were Moslems, Jews, Christians, and even some Mongol pagans.[15]

Mevlana had a completely different view of his surroundings and the turmoil in the country. He saw the world around him:

> The world is nothing. We are nothing.
> Our life in this world is nothing but dreams and images.
> As such, why do we keep struggling?
> If the person who is asleep knew he was dreaming,
> Should he suffer from his nightmare?

Divan, vs. 219

He knew God's favor:

> You gave me so many favors,
> I am tempted to ask for more,
> Like Moses when he heard the voice of God
> Wanted to see His face.
>
> *Divan, vs. 225*

He invited everyone to join him then (and still does):

> You became a doorkeeper for every villain
> Under the roof of this sky.
> Why don't you come to our quarters,
> So you can see the roof and the door?"
>
> *Divan, vs. 296*

After Shems, music and Sema kept Mevlana alive. Formal and informal religious and mystical ceremonies went on day and night. He did not eat or sleep, just recited poems such as:

> The words are piled
> And spread all over my heart.
> Each one of them begging
> Me to come out first,
> So they can rest a little while.
>
> *Divan, vs. 32*

Hearing his poems people forgot praying and joined in the dancing. Craziness spread all over Konya under the watchful, critical eyes of strict religious groups, but nobody dared to stop Mevlana, thanks to Pervana, prime minister of the Seljug government, and Sadreddin Konevi, the religious leader of Konya.

> I'll give all my heart to the one
> Who is affected with my disease.
> The sick ones should drink me like Elixir.
>
> *Divan, vs. 317*

Mevlana simply continued singing his poems and telling everyone:

> If they spread my exuberance to the Universe,
> You wouldn't see anyone sane.
> Everybody will lose his mind.
>
> *Divan, vs. 353*

Oh, Moslem, oh, Moslem, watch your hearts.
Get out of my way.
Don't look at me, don't make up to my heart.
Don't try to please me.

Divan, vs. 355

He asked everyone about Shems. Did they know what had happened to him? Maybe. Maybe not. Apparently nobody was eager to talk.

I am shedding blood from my eyes
Since the absence of the Greatest of the Great,
Shems of Tebriz.

Divan, vs. 415

Oh, Mind, oh, understanding,
You talk like you've seen him.
How can you see him
And still have your mind?
For God's sake,
You have no sense, no understanding.

Divan, vs. 426

Later, he set out on a journey to Aleppo to look for Shems. There he realized that Shems was within him, not in Aleppo. He explained:

I look like a sick falcon
Grounded because of sickness.
I neither belong to the people on earth
Nor am I able to fly to the sky.

Divan, vs. 356

Every time I remember
The hand of the King,
My heart burns with fire.
I don't have the wings to fly.
My wings are not helping me.

Divan, vs. 357

Oh, poor falcon,
How can you live with these ravens?
You committed hypocrisy,
Closing your eyes to love
When fire glitters in your heart.
How can you hide love when tears
Flow from your eyes like fountains?

<div style="text-align:right">Divan, vss. 358-359</div>

He came back to Konya much calmer and rediscovered Selaheddin at the Bazaar of the Goldsmiths. During this period his son, Sultan Veled, married Selaheddin's daughter.

These were the happiest ten years of Mevlana's life. He had found peace with Selaheddin, who was illiterate but enlightened by Seyid Burhaneddin (Mevlana's teacher). Selaheddin was also very fond of Shems.

Mevlana's eldest son, Sultan Veled, said in *Iptidaname*, "Selaheddin talked heart to heart, not mouth to mouth."[16] Apparently he was able to convey his feelings and his thoughts without words.

Selahaddin died December 29, 1258, and his funeral was carried out according to his will with full music and dances to the burial site. He was buried next to Mevlana's father. His burial night was called "Wedding Night" (Sheb-i Arus).

In the Divan, there are more than seventy poems for Selaheddin.

After Selaheddin, Mevlana chose Husameddin as his confident (Khalifa).

Mevlana's son, Sultan Veled, and Sipahsalar both indicated that Husameddin served Mevlana approximately ten years. There is a fifteen year difference between Selaheddin's death and Mevlana's death. It may be that Mevlana announced Husameddin as his successor five years after the death of Selaheddin.

On one occasion Mevlana explained, "Shems was a Sun. Selaheddin was the Moon, and Husameddin is like a star. Since all of them carry you to God, accept all three as just one."[17]

According to Eflaki, "Husameddin was very eloquent, pious and God-fearing. He distributed the revenue of the college among the disciples to the penny."

Eflaki continues, "Not only were all the revenues of the college, arising from its endowments, committed by Celal to the sole administration of Husameddin, but whatever gifts and contributions were offered by princes and friends, in money or in kind. They were all consigned to his care to augment the resources of the general fund. Celal's family, also his son, though often pinched, fared as the disciples."[18]

Apparently, Husameddin was Shiite and wanted to change his school, but Celal recommended that he remain what he had always been. Husameddin was also very close to Shems.

Husameddin's most important contribution to humanity was being the facili-
tator of *Mesnevi*, Mevlana's teachings in the form of lectures. Because of
Husameddin's suggestions and his continuous help, Mevlana was able to recite
six volumes of *Mesnevi*. Mevlana actually wrote only the first eighteen verses.

According to Golpinarli, Mevlana started the *Mesnevi* before 1258, since at
the end of the first volume, Mevlana stated that the Abbasid Khalife was still
in power. The Mongols invaded the Abbasid and took Bagdad in 1258.[19] The
writing lasted until the end of Mevlana's life.

> If temporary life is ended,
> God gives another life.
> There, there is a life with no end.
> Love is the water of life,
> With a new living in every drop of that sea.
>
> *Rubai*

Mevlana felt the Sheb-i Arus (Wedding Night) was not that far off for him.
During the last days of his life continuous earthquakes shook the city. People
were scared and asked Mevlana for help. "Don't be afraid," he said. "Earth
is hungry. Very soon he will have a mouthful. The house of earth trembles
with quakes because you are about to move your house."[20]

He recited poems until his last breath.

> God created me from Love,
> The wine of Love.
> Even if Death crushes me,
> I am still the same Love.
>
> *Rubai*

> Death is different living for the Exalted One.
> His Soul becomes calm and settled.
> Death is Union, not torture and suffering.
> It's different than the ignorant one
> Who dies all the time.
>
> *Rubai*

December 17, 1273 at about sunset, Mevlana closed his eyes to this world
and was buried in the heart of his Beloved Ones.

> Always stay with me, and remember me
> So that I can be of help to you.
>
> *Rubai*

Rubai

The Rubai, or quatrain, is a form of poetry that expresses one complete idea or meaning in four lines.

The Rubai has been known in classic Islamic literature since the 10th century. Not until the late 1850s did an English gentleman named Edward Fitzgerald convince a publisher in England to print a few hundred pamphlets of his translation of the *Rubaiyat of Omar Khayyam*, which carried the publisher's name, but not the author's. The *Rubaiyat* did not sell until the price was reduced from five shillings to a box of cheap books priced at a penny each. However, because of that initial failure, Khayyam's *Rubaiyat* turned into a great success. Edition after edition of hard, soft, illustrated, unillustrated, even pocket-size were printed.

Since then, whenever "Rubaiyat" is mentioned, Omar Khayyam immediately comes to most Western minds, thanks to the translations of Edward Fitzgerald.

Surprisingly, it took another English gentleman, A.J. Arberry (1905-1973) to publish the *Rubaiyat of Celaleddin Rumi* for the first time (London 1949). Actually, Mevlana had been introduced to the West much earlier through his *Mathnawi* (E.H. Whinfield, 1857 - London; James W. Redhouse, 1881; and Reynold A. Nicholson, 8 volumes 1925-40).

His *Divan* and mainly his Rubais have been only partially discovered. The three translators who are responsible for this partial discovery are Nicholson in *Selected Poems from the Divan-i Shems-i Tebriz*; Arberry in *Mystical Poems of Rumi*; and Annemurie Schimmel in *Dschelaladdin Rumi, Aur dem Divan*.

There are 1765 Rubais in the *Divan*, starting with the second volume. Most are written in Farsi, some in Arabic, and a few in Turkish. They can be classified in two groups, one group is didactic, and the other is lyric to overflowing in showing the love of God.

Mevlana Celaleddin Rumi

1151-1152 Birth of Bahauddin Veled (Sultan Ulema).

1184 Birth of Mevlana Celaleddin Rumi.

1203 *Divan* (v.252) mentions war of Kharezm-Gor.

1207-1212 Semerkand's siege by the Kharezm-Shah (E.S.W. Gibbs Memorial, 1916). *Fihi Mafih*: Mevlana was there.

1221 Mevlana's family leaves Balkh for unknown reasons.

1228 Marries Gevher Hatun.

1229 Arrives in Konya.

1231 Death of Bahauddin Veled (Mevlana's father).

1232 Arrival of Seyid Burhaneddin.

1233-1239 Mevlana's travels to Aleppo and Damascus.

1240 Death of Burhaneddin.

1244 October 23. Shems arrives in Konya.
Shems meets Evhaddaddin (D.1237) and
Ibn i Arabi (D.1241).
Because of these meetings, Mevlana and Shems should be
around 60 to 62 years of age.

1246 February 15, Shems leaves Konya the first time.

1247 May 8. Shems returns to Konya and marries Mevlana's
stepdaughter, Kimya.

1247 December 5. Shems is assassinated one week after the
death of his wife.

1247-1248 Mevlana visits Aleppo twice, maybe searching for Shems.

1258 Mevlana starts *Mesnevi*, ends shortly before his death.

1258 December 29. Selaheddin's death.

1273 December 17. Death of Mevlana Celaleddin Rumi.

Selected Rubais
from Divan-i Kebir

Mevlana cannot be contained in any number of volumes of his books.
And yet his *Mesnevi* is about 25,600 couplets.

His *Divan* is 44,834 verses, with 1,764 rubaies.

He also has *Mektubat* (letters), *Mecalis-i Seba* (Seven Sermons), and *Fihi Mafih*.

All the scholarly works done by Nicholson, Winfield, Arberry, Golpinarli, Furuzanfar, Schimmel, Chittick, and others, are skillful dissections of Mevlana's perception, which goes far beyond the three dimensional time and space realities.

My humble contribution of a few Rubais came from the second volume of the *Divan* and is just a glimpse of this unmatched treasure. My source was two volumes of *Divan-i Kebir*, collected and written in 1368, registered number 68-69 at Mevlana's Museum in Konya, Turkey. Golpinarli has translated *Divan-i Kebir* in Turkish in seven volumes over the period between 1950 and 1973. I owe him great respect and gratitude.

Selected Rubais
from
Divan-i Kebir

Come again, please, come again,
Whoever you are.
Religious, infidel, heretic or pagan.
Even if you promised a hundred times
And a hundred times you broke your promise,
This door is not the door
Of hopelessness and frustration.
This door is open for everybody.
Come, come as you are.

□■□

Be like the Sun for Grace and Mercy.
Be like the night to cover others' faults.
Be like running water for generosity.
Be like death for rage and anger.
Be like the Earth for modesty.
Appear as you are.
Be as you appear.

□■□

I am measured, measuring Your love.
I am worn, wearing Your love.
I cannot eat days, sleep nights.
To be Your friend
I became my own enemy.

□■□

Not before the minarets and mosques come down
Will there be many Dervish around.
Until Faith becomes Heresy
And Heresy becomes Faith,
No one will become Moslem.

□■□

I have been plunged in Your love.
What's the use of advice?
I have drunk the venom.
What's the use of sweet?
They ordered chains on my feet;
It is my heart that is insane.
What's the use of chaining my feet?

□■□

If I want to mention anybody,
 It must be You.
If I open my mouth,
 It's just to talk about You.
If I am happy,
 It's because of You.
If I am up to no good I can't help it.
 I learned it from You.

□■□

If you could get rid
Of yourself just once,
The secret of secrets
Would open to you.
The face of the unknown,
Hidden beyond the universe
Would appear on the
Mirror of your perception.

□■□

Night has passed.
We are still asleep,
Dreaming our dreams.
We are the loved and beloved,
The garden, rose and nightingale.

□■□

First, He pampered me with a hundred favors,
Then melted me with the fire of sorrows.
After He sealed me with the seal of Love,
I became Him.
Then, He threw my self out of me.

□■□

Why are you chasing shadows all the time?
What do you want to wash from your eyes
With your blood?
You are God from head to foot.
Oh naive one, what are you looking for
Beyond yourself?

□■□

Isn't it bizarre that His love
Could fit in my heart,
Thousands of souls be contained in my body,
Thousands of harvests be represented
In a piece of grain,
And thousands of universes pass through
The eye of a needle?

□■□

Ask from me a love
Which leads you to total insanity,
Things like losing one's life or mind,
An adventure of hundreds of long days.
Ask about the fire and blood
Of hundreds of deserts.

□■□

Really, your soul and mine are the same.
We appear and disappear with each other.
This is the real meaning of our relations.
Between us there is no more me and you.

□■□

Believe me, everything which appears
Is shadows and images.
The hand which draws them is the hand of God.
This magnificent lie doesn't reach
The magnificent truth.
The known exists because of the unknown.

□■□

I am a river.
You are my sun.
You are the medicine
Of my broken heart.
I fly behind You, windless.
I am a needle.
You are my magnet.

□■□

Since I have heard of the world of Love,
I've spent my life, my heart
And my eyes this way.
I used to think that love
And beloved are different.
I know now they are the same.
I was seeing two in one.

□■□

words

The wounds you inflict
Are better than others' care.
Your greed is more gracious
Than others' generosity;
Your torment more healing
Than others' solace;
Your curse more desired
Than others' praise.

◻■◻

Time will cut short this uproar.
The wolf of Death will tear apart this flock.
So many heads have such great ideas,
But the slap of Death will stop them all.

◻■◻

The secret of madness is the source of reason.
A mature man is insane for Love.
The one who has his Heart together
Is a thousand times stranger to himself.

□■□

The lover loses his way at the night of union
To that beautiful one whose trace doesn't appear.
At the night of union he sees the stars upside down,
Because his pupils bother his eyes.

□■□

A person is not in love
Unless it lights his Soul.
He is not a lover
Unless he turns like stars around the moon.
Listen. Leaves do not move without the wind.

□■□

If you follow your lust, your desires,
I tell you, you'll go out of here empty-handed.
If you want to see where you are going,
You should control your desires and your fancies.

□■□

You cannot see us with that old spell.
You cannot keep us in this borrowed house.
You cannot chain the person
Whose chain is His hair.

□■□

If you look carefully, you'll see
Every particle in the air,
Happy or unhappy, is plunged
Into the Sun of the Absolute Universe.
Every particle is as drunk
And crazy as we are.

□■□

There is a road from my Soul to my Heart.
My Heart stays awake, keeps this road open.
My Heart is like water, pure and clear,
Which becomes a mirror to the moon.

□■□

Union . . . that's the garden of Heaven.
Separation . . . Hell's suffering.
Permanent love in the universe
Always stays covered
And makes naked the one
Who has a cover.
That is the subtle point.

□■□

Oh, soul, who is your Love? Do you know?
Oh, heart, who stays in you. Do you know?
Oh, flesh, you are looking
For a way of escape with deceit.
Who is pulling you to Himself?
Look. Who is searching for you?

□■□

The Universe was filled with miracles.
When love's dew was mixed with human mud,
Hundreds of scalpels of love
Entered the veins of Soul and picked one drop.
That's what is called Heart.

□■□

You are not made of water and earth.
You are not from this whirling universe.
The body is a river
And Soul is the running water of life there.
But, where you are,
You are not aware of either.

□■□

How long am I going to tell
The color and smell of time?
It must be time to see that Beauty.
When I look at Him I see myself,
And when I look at myself, I see Him.

□■□

Oh, Love, we are closer to you than Love.
We are the ground You walk on.
Is it fair in the Creed of Love
To see all the universe through You,
But not to see You?

□■□

One has to be mature in the way of love.
One has to be out of all Earth's problems.
Cure your own blindness.
Truth fills the universe.
Do you have eyes to see it?

□■□

Death is different living for the Exalted One.
His soul becomes calm and settled.
Death is union, not torture and suffering.
It is different than for the ignorant one
Who dies all the time.

□■□

I picked one rose in a hurry.
I was afraid of the Gardener.
Then I heard the soft voice of Him,
"What's the value of one rose?
I give you the whole garden."

□■□

We have nothing but love.
We have no front, no beginning, no end.
The soul yells and screams inside of us,
"Oh, lazy one, this is the way of Love.
Reach me, reach me, reach me!"

□■□

I want to go away
Hundreds of miles from the mind.
I want to be free from good and bad.
So much beauty is behind this curtain.
Here, there is my real Being.
Oh, you ignorant ones,
I want to be in love with myself.

□■□

I cannot sleep when I am with you
Because of your love.
I cannot sleep without you
Because of my screaming and yelling.
I am awake on both nights,
But what a difference in between.

□■□

Your hands, your feet, your eyes are two.
That's the way it is.
But it's wrong to say Heart and Love are two.
Love is a pretext. The Loved One is God.
It is absurd even to think that He is two.

□■□

At the dawn of Eternal Love
Souls fly out of bodies
And man reaches the stage of perception
Where with every breath
He can see and touch
Without eyes and without hands.

❑■❑

I am drunk with You,
Not with wine.
I become insane.
Don't look for reason from me.
My exuberance flows on rivers.
My whirling wonders turn the stars.

❑■❑

Although reason can't contradict You,
Religion is in Your charge.
Science can't comprehend You,
But doubt stays in Your trap.

□■□

This valley is different,
Beyond religions and cults.
Here, silently, put your head down.
Engulf yourself in the wonder of God.
Here, there's no room for religion or cults.

□■□

My soul glowed from the fire of Your love.
Your world was a whispering water
At the river of my heart.
That water turned into a mirage,
And the fire into lightning.
The story is ended.
Surely those things were only
Illusions and dreams.

□■□

This is not spring.
This is another season.
Sparks from each eye
Come from different dreams.
Although all the branches
Dance at the same time,
Each one moves for another means.

□■□

While burning with my own fire,
I once wanted to forget You.
I have a soul
Which makes my mind drunk.
Please come into my cup.
I want to drink You.

□■□

At the beginning, while consoling
Myself with His love,
The neighbors couldn't sleep
Because of my screams.
Now, my screams have ceased.
My love increased
Just like smoke disappears
When the fire glows.

□■□

He is All and None.
He creates joy and sorrow.
Why don't you see
That you are nothing but Him.

□■□

You are the water.
We are the plants.
You are the King.
We are poor.
You are the one who talks.
We are echoes.
You are the one searching.
Why don't you come to all of us once?

□■□

You are the secret of God's secret.
You are the mirror of divine beauty.
Everything in the universe is within you.
Ask all from yourself,
The One at whom you are looking is also you.

□■□

Our clay kneaded our body
From the Divine light of the sky.
Our grace and beauty make angels jealous.
Sometimes the highest spirits envy
Our purity and cleanliness.
Sometimes the devil is afraid of our vices.

□■□

We are the secret of God's treasure.
We are an ocean full of pearls.
We are part of the moon
And extend down to the fish.
We are also the ones who sit
At the throne of the Kingdom.

□■□

Oh sun, rise. Particles are dancing.
I see headless, footless spirits
Dancing with ecstasy.
Some are dancing at the dome of the sky.
Come close.
I'll tell you where they are going.

□■□

I am a soul who has had
A hundred thousand bodies.
But I can't talk about it.
What can I do?
I am tongue-tied.
I have seen thousands
Of people who were all me.
But from them I haven't found
Any like me.

□■□

They said, "Love is the end of silence.
The beginning is chaos.
The end is tranquility."
The Soul is the stone in the mill.
All these restless appearances are
Turning parts, fragments of the stone.

□■□

The secret chemist mixed the earth
With the Divine substance.
Man came into existence.
When the Divine secret is broken
Earth goes to earth.
Substance goes to the Divine.

□■□

When my essence became
An ocean for the universe,
Every particle in my body shone.
When I burned out like a candle
In the way of Love,
All the past, present and future
Became Absolute Time.

□■□

At last I understand
Love depends on me.
I hold a thousand curls of its hair.
Yesterday, I was drunk with the cup.
Today, that cup is drunk from me.

□■□

Who is more miserable
Than the lover without patience?
This Love is a disease
Without remedy or fantasy.
The cure of Love
Is neither hypocrisy nor moderation.

□■□

Last night I asked an old wise man
To tell me all the secrets of the universe.
He murmured slowly in my ear,
"This cannot be told, but only learned."

□■□

Love asked me last night, with pity,
"How could you live without Me?"
"I swear," I said,
"I am like a fish out of water."
"It is your fault," he answered.
"You are the one fleeing from Me."

□■□

I want to talk to you without language.
I want to tell you things secret to your ears.
Even if I said them among strangers,
Nobody understands except you.

□■□

Oh, borne one, this is the fate of humans.
Lightning comes from the clouds, which rain pearls.
Whatever you say comes from comparison.
But He tells what He sees.

□■□

If you can't smell, don't come to this side.
If you can't undress, don't plunge into this river.
There is a place from which all places originate.
Stay there; don't come to this side.

□■□

Oh, one doesn't know the essence inside,
The one who is proud and fond of skin.
Come to your senses. There is a love
Inside of your Soul.
Perception is the essence of your body.
Soul is the essence of your perception.
But if you go beyond body, perception and Soul,
Everything becomes He.

□■□

Oh, Love, everyone is awakened
With your awareness.
Everyone who sleeps,
Sleeps at your door of Grace.
There is no other Secret One all around.
I am afraid to talk more than that.

□■□

Oh reason, go away.
There is no wise one here.
Even if you become a small hair,
There is no place for you.
It is morning now.
Whatever candle you burn
Would be shamed in front of sunshine.

□■□

This universe, the ultimate
Limit of our perception,
Is nothing but a stick
In the hand of God.
Every drop, every particle,
Every creature appears and disappears.
They look like fish in the sea.

◻∎◻

This clay body is my heart's glass.
This balance, mature thoughts,
Are the raw wine of heart.
This bit of knowledge
Is a trap to the heart.
I am telling this, but the words
Come from the heart.

◻∎◻

The one who shares your trouble
Is the one who cuts your head.
The one who puts a crown on your head
Is your source of trouble.
Adding more load on you makes you a burden.
Your friend takes you away from you.

□■□

That pure, simple fire which consumes you
Is better than hundreds of lustful fires.
Even when it is not pure,
Look how many beauties come
After the fire of lust.

□■□

Wherever you are, there is a lot
Of grief, fights and torment.
But when you are absorbed and annihilated by us,
There's lots of favor and loyalties.
If you're honest, everything we have is yours.
If not, we'll turn your left to the right.

□■□

In our head, there is an entirely different zeal.
Our love is an entirely different beauty.
For God's sake, we are not satisfied with only love.
Another spring is coming after this fall.

□■□

Tonight, the image of
That beautiful One came swiftly,
Looked for my heart's place.
When he found it, he drew his knife
And plunged it into my heart.
Bless that most beautiful One.

□■□

Destiny is not under control of our heart.
Being is the means of reaching non-Being.
There is someone who looks after us
From behind the curtain.
In truth, we are not here.
This is our shadow.

□■□

I am a mountain.
My words, my sounds are from my beloved.
I am a painting.
My beloved is my painter.
Did you think these are my words?
They are the sounds
Which come after the key turns in the lock.

□■□

This is the love which brings
A lifeless body to life.
How come this love is so beautiful, so sweet?
Is it inside of our body or outside?
Oh, I wonder if it is in the gaze
Of God's Sems of Tebriz.

□■□

Thousands struggle for the table of Eternity.
They have eaten; they are still eating.
The table is the same table; nothing is missing.
Just like a bird
Which landed on top of the mountain,
Then flew away,
Nothing was added or taken away.
The mountain remains the same.

◻◼◻

What is this mischief in my squeezed heart?
What is this love bent like a harp?
Why is this heart fighting with me
Day and night for Him in my body?

◻◼◻

If you sit with someone
But your heart doesn't feel good,
Your mind stays confused
And hasn't been cleaned from the daily mud.
Don't get in his conversations.

□■□

Somebody inside of your breath
Also gives you breath, promises of Union.
Breathe with Him until your last breath.
He gives you that because of kindness and grace,
Not as a joke.

□■□

Whoever sees You with his head's eye
Smiles with his beard, his mustache.
Whoever compares You with himself
Has thorns in his eyes, many thorns.

□■□

Don't be idle and just stand there.
Come in. Join us.
The person without work either eats or sleeps.
Here is Music. Here is Sema.
Come in. Join us!

□■□

"Who is the One," I asked,
"That adds Soul to our Soul,
Gives life right from the start?"
Sometimes He covers our eyes like a Falcon.
Sometimes He hurls us after the Prey.

□■□

Oh One whose heart is like an ocean,
Play, spend all your coral and pearls.
There is no room for stinginess.
The body opens its mouth like a shell.
"Oh," it says, "If Soul couldn't find the way,
How am I going to fit there?"

□■□

How nice, sweet and clean
We were as Souls without bodies.
Our Lord would do us a favor
To kindly exempt us
And recreate us as we were before.

□■□

If temporary life is ended,
God gives another life.
Here, there is a life with no end.
Love is the water of life
With a new living in every drop of that sea.

□■□

Our Prophet's way is Love; we are the Sons of Love.
Our Mother is Love: O, Mother, the one who is
Hidden inside the clothes of our body;
O, Mother, the one who is
Afraid of our bad nature.

□■□

There is a Soul inside of your Soul.
Search that Soul.
There is a jewel in the mountain of body.
Look for the mine of that jewel.
Oh, Sufi, passing by,
Search inside if you can, not outside.

□■□

Since we see others, we are not one anymore.
We are with the numbers.
When we understand good and bad, all become bad.
The heart which hasn't gone beyond itself
Would always be beneath the feet.

□■□

"I'll fly like a pigeon from your hand."
"If you fly, you deserve to be
Chained with my grief," he answered.
I said, "I am tired and weak,
Dying from your love."
"Death would be an honor for you," he said,
"If you die with My love."

□■□

Anyone who joins our Way
Sees hundreds of Souls in our body.
He becomes so drunk
For our kind of wine,
He sees days in our nights.

□■□

I see an eye in every fortune,
And a fortune sits in every eye.
Oh, cross-eyed one,
If you see two in one,
I only see one in two.

□■□

If I said, "I reach for your hair,"
Believe me, it is not symbolic.
It is the truth. I have seen my heart
In the curls of your hair
And fallen in love with my heart.

□■□

Faith in the religion of Love is different.
Drunkenness from the wine of Love is different.
Everything you learn from school is different.
Everything you learn from Love is different.

□■□

Today, even, I am a drunk.
I want to turn around.
I want to make a wine cup from a skull.
Today, I want to look for a wise man in town
To make him crazy.

□■□

Once we were pupils and now become the Master.
Once we were happy to see a friend's face.
I wonder what happened at the end of our adventure.
We came like clouds and passed like a breeze.

□■□

When the Sun of spirit shines,
Sufis dance like particles.
They say Sema is a devil's game.
Yes, such a pleasant devil
That brings life to the Soul.

□■□

You have been the slave of cold winters,
Lived away from nightingales and rose gardens.
Wake up! This is the time.
If you miss it, it will never return.

□■□

Your face is like a Sun beyond the sky.
Your beauty cannot be manifested.
While your love is within me,
You are still beyond the Universe and Soul.

□■□

On the Day of Judgment
Lots of persons will come,
Their faces terrified by fear.
I'll put Your love in front of me
And ask it to answer my account.

□■□

Don't treat me as a stranger.
I am your neighbor.
My house is close to yours.
I may look different, but my heart is good.
My inside is shining even if my sayings are obscure.

□■□

In love, there is no high or low,
No bad behavior, no good behavior,
No leader, no follower, no devotee;
Just indifference, tolerance and giving up.

□■□

The most Beautiful One looked at my pale face.
"No way," he said. "Don't expect Union.
You have been next to your Love a hundred months.
I am in Spring. You still have the face of Autumn."

□■□

If I am bad, you are a sober, well-behaved priest.
Don't harm me. Get out of my way.
Don't boast with your praying and fasting.
This is not the gate which goes to your bridge.

□■□

The beloved walks around lonely places
Where loved has passed by.
The devout prays on his Rosary beads.
One sleeps at the edge of the water.
The other begs for a slice of bread.
They suffer from thirst and hunger.

□■□

We are happy even if we don't have wine and cup.
We'll be pleased if they call us good or bad.
"There'll be no end for them," they said of us.
We are filled with joy at having no end.

□■□

"Come to the garden in Spring," You said.
"All the beauties, wine and light are there."
What can I do with them without You?
And if You are there, why do I need them?

□■□

When I miss your lips,
I kiss the red stone of the ring.
If your lips are not around, I kiss the ring.
If I cannot reach your sky,
I prostrate myself and kiss the ground.

□■□

Who isn't completely annihilated from Being
Cannot be verified in Union.
Union is not the incarnation of God in Man.
Union is Self-annihilation.

□■□

The lover should be disgraced, scorned,
Crazy and insane all year long.
When we are sober, we are the slave of everything.
When we become drunk, whatever will be, will be.

□■□

When I am quiet, he wants me to scream.
When screaming, he asks me to be quiet.
When I am calm, he wants me to be exuberant.
When exhilarated, he asks me to be still.

□■□

Who said that an immortal man has died?
Who said that the Sun of Hope has faded?
The enemy of Hope closed his eyes at the roof,
And said the Sun is buried in darkness.

Rubai probably written in grief, denying the death of Shems.

□■□

It is wonderful to move
To a new place every day.
It is wonderful to flow
Without ice and mud.
Everything, my friends,
Is gone with yesterday.
All the words are gone.
Now is the time to say something new.

□■□

Here is the garden; here is the spring.
Oh, Soul, let's stay here.
Oh, Soul, take your cover off.
Let's be comfortable, You and I.
Nobody else is at the house, oh, Soul.

□■□

As Hallac Mansour said, "I am God."
He was sweeping the ground with his eyelashes,
Plunging into the ocean of his Nothingness,
Brought and pierced the pearl of "I am God."

□■□

All around is green. Flowers are everywhere.
All particles smile with reflection of Beauty.
Everything sparkles like jewels.
Love and Beloved are united everywhere.

□■□

Even if you are a slave behind this curtain,
Once you come to this side,
You'll see what a King you are.
People call this the "Water of Live."
But once you arrive,
You could drown at the side of our River.

□■□

Close your eyes. My heart will be an eye for you.
With this eye, another world will be shown to you.
When you decide not to be conceited,
Everyone will be admiring you.

□■□

I don't know who sits in my Heart
Or why He smiles at me.
I am not at all myself.
My Heart is like the stem of a rose
Which lost its leaves on the morning breeze.

◻◼◻

You are who makes all my troubles go away.
You cause the cedar, rose and garden to lose themselves.
The rose is mellow. The thorn is drunk.
Give us one more cup so we will all be the same.

◻◼◻

Last night He was shining like a moon.
His beauty was brighter than the sun.
Our imagination wouldn't reach
All I know of its goodness.
I don't know who He was.

□■□

There's no way this Heart can escape You.
Oh, Love, You may as well take it.
If the pain of Love doesn't fill this Heart,
I don't care if I have it or not.

□■□

I am an ocean, not a drop.
Not conceited nor cross-eyed.
If I chat with a particle through my heart,
The particle screams, saying, "I am not."

□■□

My Love told me, "You ask
A kiss from every Beauty.
Why not from me?"
"Would you like gold?" I asked.
"No," He said. "Just your life."

□■□

My heart is so full of your love,
Everything else has disappeared.
Make me forget books, science and temperance.
Teach me only lyrics, poems and rubiayats.

□■□

Who looks for a garden, sees You.
Who thinks of wine and candle, loves You.
They say, "Sleep is food for the brain."
Who has seen a Lover, who cares for his brain?

□■□

How come my Love becomes so bloodthirsty?
The Soul tries to flee from its cage of flesh.
Impious is the one who doesn't sin
With Your sweet lips when he has a chance.

□■□

The wine which is forbidden to the people
Is permissible for the Dervish.
They keep drinking.
Cupbearer, come on, don't tell us it's enough.
Where is our beginning. Where is our end?

□■□

Footnotes

[1] Golpinarli, A., *Mevlana Celaleddin*, 4th ed. (Istanbul: Publisher, 1985), p. VI.

[2] This rumor came after Sultan Veled and Sipahsalar mentioned it, and later Eflaki added a false family genealogy.

[3] Bediuzzaman Firuzanfer, *Risals der tahkeyke Ahval u Zindegani, Mevlana Celalledin Muhammed Meshur be Movlovi* (Tehran: Caphane-i Meclis, 1315 H.S.), p. 344

[4] B. Lewis, *The Political Language of Islam* (Chicago: University of Chicago Press, 1988), p.7.

[5] Lamb, Harold, *Genghis Khan* (New York: Garden City Publishing, 1927), p. 133.

[6] Sultan Bahauddin, *Maarif* (Istanbul: Istanbul University, 602 in Farsi; rpt. 994 in Persian; rpt. 1084 in Farsi), V. III, p. 203a.

[7] Eflaki's account of the journey. Eflaki, Shemseddin Ahmad-Al, *Legends of the Sufis: Selected Anecdotes from the Work Entitled Menaqibu L'Arifin*, trans. James Redhouse (London: The Theosophical Publishing House Ltd., 1977), p. 2.

[8] Eflaki, *Ibid*, p. 4.

[9] Eflaki, *Ibid.*, p. 11.

[10] Sultan Veled, *Iptidaname* (Istanbul University Library: Handwritten, 1380 H.S.), p. 196-197.

[11] Golpinarli, *Mevlana Celaleddin*, p.150.

[12] Susud, Hasan Lutfi, *Fakir Sozleri* (Istanbul: Dogan Kardes Yayinlari, 1958), p. 17.

[13] Susud, Personal Letters, 1956-1985.

[14] Eflaki, *Op.Cit.*, p. 42.

[15] Eflaki, *op. cit.*, p. 86.

[16] Eflaki, Shemseddin Ahmad-Al, *Managib al-Arifin* (Ankara: Turkish Ministry of Education, Publisher, 1953-54), in Persian, p. 60.

[17] Sultan Veled, *Iptidaname* (Istanbul University Library: Handwritten, circa 1250), p. 113.

[18] Eflaki, *Op. Cit.*, p. 104.

[19] Golpinarli, *Op. Cit.*, p. 120.

[20] Eflaki, *Op. Cit.*, p. 84; Mevlana, *Divan*.

Bibliography

Arberry, A.J. *The Rubaiyat of Jalaluddin Rumi.* London: E. Walker, 1949.

Bahauddin, Veled. *Maarif.* Istanbul University: Handwritten, 602 in Farsi; rpt. 994 in Persian; rpt. 1084 in Farci.

Bahauddin, Veled. *Divan.* Ed. M.N. Uzluk. Ankara: Handwritten, circa 1230.

Bedi-Uzzaman Firuzan-fer. *Risals der tahkeyke Ahval u Zindegani, Mevlana Celalledin Muhammed Meshur be Movlovi.* Tehran: Caphane-i Meclis, 1315 H.S. in Persian.

Cami, Lamii. *Nafahat.* Istanbul: Handwritten, 152 in Turkish.

Eflaki, Shemseddin Ahmad-Al. *Managib al-Arifin.* Ankara: Turkish Education Ministry, 1953-54 in Persian.

Eflaki, Shemseddin Ahmad-Al. *Menaqibu' L'Arifin.* Trans. James Redhouse. London: The Theosophical Publishing House, Ltd., 1977; rpt. Coombe Springs Press, 1976, 1965; rpt. Trubner & Co., London, 1881.

Eflaki, Shemseddin Ahmad-Al. *Tahsin Yazici.* Istanbul: Turkish Beyazid Library, 1953; rpt. 1959.

Golpinarli, A. *Mevlana Celaleddin.* 4th ed. Istanbul: Inkilap Kitabevi, 1985 in Turkish.

Lamb, Harold. *Genghis Khan.* New York: Garden City Publishing, 1927.

Mevlana Muhammed Celaleddin. *Divan-i Kebir.* 2 vols, n.68-69. Ed. Osman Og Hasan. Konya Mevlana Museum: Handwritten, 1363 in Persian.

Mevlana Muhammed Celaleddin. *Divan.* 7 vols. Trans. A. Golpinarli. Istanbul: Remzi, Inkilab, in Turkish.

Mevlana Muhammed Celaleddin. *Fihi Ma Jihi Bedi-Uzzaman Firuzanfer.* Tehran: Handwritten, 1330 H.S.

Mevlana Muhammed Celaleddin. *Meliha Ulker Tarikahya Fihi Mafih.* Istanbul: Turkish Education Ministry, 1954.

Nicholson, Reynold A. *Rumi, Poet and Mystic*. London: George Allen & Unwin, 1950.

Onder, Mehmet. *Mevlana*. Konya: Siirleri Antolojisi, 1958 in Turkish.

Ritter, H. *Celaleddin Rumi*. Istanbul: Turkish Education Ministry, 1944 in Turkish.

Schimmel, Annemurie. *Mystical Dimensions of Islam*. Chapel Hill: University of North Carolina, 1978.

Sipahsalar, Faridun Ahmad. *Risala dar Ahval-i Maulana Jalaluddin Rumi*. Ed. Said Nafisi. Tehran: Handwritten, 1325 H.S.

Semseddin Tebrizi. *Makaalat*. Konya Fatih Library: Handwritten, circa 1225 in Persian.

Susud, Hasan Lutfi. *Fakir Sozleri*. Istanbul: Dogan Kardes Yayinlari, 1958 in Turkish.

Susud, Hasan Lutfi. *Islam Hacegan Hanedani*. Istanbul: Dogan Kardes Yayinlari, 1958 in Turkish.

Susud, Hasan Lutfi. *Masters of Wisdom of Central Asia*. North Yorkshire, England: Coombe Springs Press, 1983.

Veled, Sultan. *Iptidaname*. Istanbul University Library: Handwritten, circa 1380 in Persian.